IMAGES OF WAR
GERMAN ARMOUR LOST ON THE EASTERN FRONT

RARE PHOTOGRAPHS FROM WARTIME ARCHIVES

IMAGES OF WAR
GERMAN ARMOUR LOST ON THE EASTERN FRONT
RARE PHOTOGRAPHS FROM WARTIME ARCHIVES

BOB CARRUTHERS

Pen & Sword
MILITARY

This edition published in 2018 by

Pen & Sword Military
An imprint of
Pen & Sword Books Ltd.
47 Church Street
Barnsley
South Yorkshire
S70 2AS

Copyright © Coda Publishing Ltd. 2018.
Published under licence by Pen & Sword Books Ltd.

ISBN: 9781473868441

A CIP catalogue record for this book is available from the British Library.

All rights reserved. No part of this book may be reproduced or transmitted in any form or by any means, electronic or mechanical including photocopying, recording or by any information storage and retrieval system, without permission from the Publisher in writing.

Printed and bound in England
By CPI Group (UK) Ltd., Croydon, CR0 4YY

Pen & Sword Books Ltd. incorporates the imprints of Pen & Sword Aviation, Pen & Sword Family History, Pen & Sword Maritime, Pen & Sword Military, Pen & Sword Discovery, Pen & Sword Politics, Pen & Sword Atlas, Pen & Sword Archaeology, Wharncliffe Local History, Wharncliffe True Crime, Wharncliffe Transport, Pen & Sword Select, Pen & Sword Military Classics, Leo Cooper, The Praetorian Press, Claymore Press, Remember When, Seaforth Publishing and Frontline Publishing

For a complete list of Pen & Sword titles please contact

PEN & SWORD BOOKS LIMITED
47 Church Street, Barnsley, South Yorkshire, S70 2AS, England
E-mail: enquiries@pen-and-sword.co.uk
Website: www.pen-and-sword.co.uk

INTRODUCTION

In April 1938, to mark the Führer's birthday, Hitler's magnificent new army marched before him. The event was designed to intimidate the world. At the centre of the great parade were the tanks of the new German Panzer Divisions. It is true that most of the tanks were small and lightly armed but the sheer numbers added to the aura of cutting edge military might.

Hitler was a gambler and he gambled upon bluffing his enemies into believing his tank forces were far stronger than they actually were. Out of sight of the foreign dignitaries, many vehicles re-joined the tail of the columns and were driven past twice. The trick worked and served Hitler's grand design. By a combination of deceit and brinkmanship Hitler had made a chilling and spectacular assertion of Germany's re-born military might.

Ironically, the roots of the German *Panzerwaffe* were laid in conjunction with Soviet Russia, the nation that was destined to become Nazi Germany's greatest enemy and ultimately her nemesis. During the 1920s, the new Soviet Union was an even greater pariah than Germany. Somehow the fledgling Soviet state had already withstood the perils of a civil war and foreign intervention, which had seen British ground troops deployed in an attempt to assist the White Russians. Clearly Moscow could not look to London or Paris for aid, so she turned instead to her former adversary. German/Soviet tank development began at Kazan, located deep inside Russia where secrecy was relatively easy to maintain. The fruits of those clandestine operations were to be seen in action as the Soviet and German tank forces of 1941 locked horns in earnest.

As a result of General Heinz Guderian's efforts, in 1935, the first Panzer Divisions were formed. These revolutionary formations incorporated a tank brigade with 561 tanks providing the main firepower. A great deal of accurate thought had gone into the development of the Panzer Division, which also included motorised infantry, reconnaissance and artillery. The resulting Panzer Division was a well-balanced force that could call on the support of any or all of the component parts to capture an objective. The purpose of the Panzer Division was to launch a speedy advance, break through into enemy territory and spread confusion, fear, and panic in the enemy command and communication systems. One further innovation was the close link with the Luftwaffe, who could add even more firepower when needed.

Although comparatively few in number the mechanised and armoured units of the Second World War were the only truly modern component of the German Army and were the key to much of its extraordinary success. The military of many countries were familiar with wireless technology, with tanks and with war planes, but only in Germany were these elements so effectively combined to form fully integrated fighting units with exceptional striking power. The term blitzkrieg had first appeared in 1935, in a German

Heinz Guderian.

military periodical *Deutsche Wehr* (German Defence), in reference to sudden assaults that characterised the new combined arms tactics. The new breed of German tactics were successful in the campaigns of 1939-1941 and by 1940, the term blitzkrieg was being extensively used in the Western media.

It is difficult now to imagine that such small and lightly armoured tanks could spearhead the devastating operation of blitzkrieg. The secret of their success was speed and co-ordination of effort. In reality, the remarkable string of German successes was due less to superiority of military technology than to the excellence of German methods and training. Many of the early German Panzer Division were equipped only with Panzer I and II light tanks. It was the new way of waging war, which came as a hammer blow to Germany's opponents forcing them to radically rethink their own military tactics.

Hitler's Generals had certainly rewritten the rule book of battle. In Poland, it took less than a month to dispose of a large but poorly equipped Polish army that had fought along rigidly traditional lines. In France, the German army successfully challenged the largest and most modern army in Europe.

Only a year later, in June 1941, even this achievement was to be eclipsed by Germany's astonishing victories in the war against Stalin's Soviet Union. Spearheaded by tank formations, German armies swept eastward. In a series of huge encirclements, thousands of Soviet tanks were destroyed and millions of Soviet troops killed or captured, and for a while it seemed that Hitler would succeed where Napoleon had failed, by conquering the vast eastern power. On the world stage the tank had now become established as a symbol of German invincibility.

In the campaigns of the early war years these new tank armies struck down all before them, although a surprisingly large number of German tanks were knocked out in Poland and in France. However, it is always the case that history is recorded by the victor, and accordingly there are precious few shots of knocked out German armour from 1939-1941. Most of the photographs in these pages are therefore from the later stages of the war when allied reporters were on hand to record the victorious efforts of their kinsmen.

Tanks came of age in the Second World War. They also developed faster and changed more in a six-year period than at any time before or since. The catalyst was the demands of a technological war. Like a crazed version of Darwin's Theory of Evolution, the Second World War accelerated the pace of design. Fast responses to a constantly changing situation were urgently needed and new designs had to be engineered, tested, and built in an incredibly short timescale. In the space of three short years, German tank technology

progressed from the lightweight and inefficient Panzer I to the mighty Tiger II (*Panzerkampfwagen* Tiger Ausf. B) – known to the allies as the 'King Tiger' or 'Royal Tiger'. This was one of the most feared fighting vehicles of the war, and an almost unbelievable leap in terms of design from the humble Panzer I.

When attacking, explosive power alone had little value against the thick armour of a tank like the Tiger II. To destroy a tank, it was obviously necessary to fire a projectile fast enough to penetrate the armour of the hull and disable the machine, or kill the men inside. This required tanks to be able to fire the heaviest practicable shell, at huge speeds. This velocity produced enough kinetic force to punch through the armour of an enemy tank. Even today, armour-piercing rounds still tend to be solid shot rounds that rely upon a very high velocity. The

The Tiger II heavy tank.

enormous pressures created by a round impacting on armour force a way through the target and fly around inside destroying equipment, or killing or injuring the crew.

The armour of most tanks of 1939 and 1940 vintage could be penetrated by relatively small calibre anti-tank weapons, however, as armour grew in thickness a variety of high explosive anti-tank rounds had to be developed. These High Explosive Anti-Tank (HEAT shells) were designed to penetrate the armour of a thickly armoured enemy tank. HEAT warheads functioned by having the explosive charge melt a metal liner in the projectile to form a high-velocity superplastic jet but its effect is purely kinetic in nature. Contrary to a widespread misconception (possibly resulting from the acronym HEAT), the jet does not melt its way through armour. However, it is unlikely that the desired effect was frequently achieved on the battlefield. It is debatable whether the small amount of explosive contained in the shells was much more effective than the massive kinetic impact of a high velocity round.

As the war progressed the German approach was to seek improved anti-tank capability by mounting the largest possible calibre of main gun with the highest practicable velocity. The larger calibre effectively gave the tank a good high explosive firing capability and the kinetic energy from the high velocity gave it a deadly killing power against other tanks. The Panther tank of 1944 vintage was considered by many to be the ultimate combination of striking power, armour, and mobility. Five times as many Panthers were manufactured compared to the much more famous Tiger I and not surprisingly images of knocked out Panthers far outweigh the surviving photographs of their more famous cousins.

Despite the undoubted promise of machines like the Panther, German tank designers were still infatuated with the idea of ultra-heavy armour and massive hitting power over mobility. Late 1944 saw the completion of the super-heavy Panzer VIII – the

A Panther production line.

heaviest fully enclosed armoured fighting vehicle ever built. The Panzer VIII was initially to receive the name *Mammut* (Mammoth), although this was later changed to *Mäuschen* (Little Mouse), and finally to *Maus* (Mouse), which became the most common name for this tank. Weighing 188 metric tons, the Maus's main armament was the Krupp-designed 128 mm KwK 44 L/55 gun. The 128 mm gun was powerful enough to destroy all Allied armoured fighting vehicles then in service, some at ranges exceeding 3,500 metres. Five were ordered, but only two hulls and one turret were completed before the testing grounds were captured by the advancing Soviet forces. It seemed that the crazed minds of the Third Reich would never give up the quest to be the strongest and the biggest, whatever the cost, but as the humble Sherman and the T-34 had proved, sometimes quantity matters as much as quality.

Of the thousands of armoured fighting vehicles constructed by the Third Reich only a handful survive today. From a historical point of view it would be fascinating to have a much wider array of survivors but the lure of the scrap man's cash will always prevail over preserving redundant military hardware.

Although many German tanks were destroyed in combat with enemy tanks and anti-tank guns, the majority met their fate as a result of allied air attacks. As the war progressed a large proportion were blown up by their own crews either as a result of breakdowns and bogging down, or from a lack of fuel. However, what we do have to share is this – the surviving photographic record of the pivotal moments that saw these ingenious and hugely expensive fighting machines transformed from world threatening military hardware into redundant scrap metal.

June 1941 – The wreckage of a 10.5 cm K gepanzerte Selbstfahrlafette of the Panzerjäger Abteilung 521 knocked out near Slutsk, Belarus. The 10.5 cm K (gp.Sfl.) was a prototype self-propelled gun originally designed as a *Schartenbrecher* (fortification breacher) for use against the Maginot Line defences. Following the defeat of France it was re-purposed for use as a tank destroyer on the Eastern Front.

29 June 1941 – A Flammwagen auf Panzerkampfwagen B-2(f) of Panzerabteilung (F) 102 burns after being hit while assaulting Soviet positions in Wielki Dzial, Poland. A number of French Char B1s tanks were captured by the Germans during the Fall of France and these were later pressed into service as second line and training vehicles under the designation Panzerkampfwagen B-2 740 (f).

1941 – The wreckage of an Sd.Kfz. 231 (6-Rad) of the 20th Panzer Division.

1941 – Panzer III of the 2nd Panzer Army, knocked out in a Soviet village. The Panzer III was the work horse of the German tank force in the early part of the assault on Russia.

July 1941 – A Panzer III Ausf. E of the 3rd Panzer Division, captured by the Red Army near the settlement of Buinichi, during the defense of Mogilev. A Sd.Kfz.253 lies in the background.

July 1941 – German tankmen next to the wreckage of a Panzer IV Ausf. D near the village of Ludoni, Russia. A Soviet T-26 can be seen in the background.

July 1941 – Red Army troops inspect a damaged Panzer 35 (t) of the 6th Panzer Division in the area of Raseiniai, Lithuania.

July 1941 – The wreckage of a Panzer III near the city of Babruysk, Belarus. The grave of the crew members is seen to the left.

1941 – A destroyed Panzer IV lying upside down on a roadside on the Eastern Front

July 1941 – A Panzer 38 (t) knocked out by Soviet artillery.

1941 – The wreckage of an Sd.Kfz. 265 kleine Panzerbefehlswagen I, of the 20th Panzer Division, on the Eastern Front. Converted from the Panzer I Ausf. B, the Kl.Pz.Bf.Wg. was a command tank which saw considerable action during the early years of the war. The Panzer I Ausf. B was used mainly in a reconnaissance role.

1941 – Knocked-out Panzer III Ausf. H. The thinness of the armour is evidenced by the clean penetration shots on the superstructure and the armour piercing round which has punched through the hull front.

July 1941 – Sturmgeschütz III disabled by a shot to the barrel on the Eastern Front.

July 1941 – A Panzer II Ausf. C of the 17th Panzer Division, destroyed during fighting in Syanno, Belarus.

20 July 1941 – Red Army infantrymen inspect a captured Nazi banner. Behind is a Panzer III Ausf. E of the 3rd Panzer Division (Wehrmacht), knocked out in the fighting around Mogilev in Belarus.

2 August 1941 – The wreckage of a Panzer III of the 9th Panzer Division. The human cost of the mechanical war is emphasised by the graves of the tank's crew members in the foreground.

Summer 1941 – Soviet forces inspect a captured Flammpanzer II. A variant of the Panzer II, the flamethrowers used were modified versions of infantry flame weapons

August 1941 – The wreckage of a Panzer II, knocked out by Soviet units, in the village of Kokkosalma, Karelia, Russia.

August 1941 – The wreckage of an Sd.Kfz. 251 Ausf. B in the Smolensk region, Russia.

August 1941 – A Soviet officer examines an abandoned Sd.Kfz 10/4 (2cm Flugabwehrkanone 30) half-track of the 61st Infantry Division.

Summer 1941 – StuG III Ausf. A destroyed by Soviet artillery in the area of Kiev.

Autumn 1941 – Panzerkampfwagen III Ausf. J of 6. Kompanie, 2nd Panzer Division. The vehicle was stripped for spare parts after being knocked out by a glacis penetration during the drive on Moscow.

October 1941 – Members of a panzer crew pose beside a knocked out Panzer IV Ausf. C of the 19th Panzer Division in the Maloyaroslavets district.

Winter 1941-42 – Soviet infantrymen studying a captured Panzer III during the Battle for Moscow.

5 December 1941 – Red Army infantrymen inspect an overturned Panzer 38(t) near Moscow in the wake of Operation Typhoon.

Winter 1941-1942 – A Panzer III abandoned by the Germans in the Kryukovo district of Moscow.

December 1941 – Red Army infantrymen inspect a 15 cm sIG 33 (Sf) auf Panzerkampfwagen I Ausf B, captured in the suburbs of Moscow.

Winter 1941-1942 – An abandoned Sd.Kfz. 251 half-track photographed on the outskirks of Moscow during the German retreat.

10 December 1941 – The chassis of a wrecked Panzer II, destroyed during the fighting in a village near Moscow. The German advance reached as far as the terminus of the Moscow tram.

15 December 1941 – Red Army troops investigate the wreckage of an Sd.Kfz. 10/4 half-track in the town of Klin, located 85 kilometers northwest of Moscow.

Winter 1941-42 – A soviet officer inspects a knocked-out Panzer IV (7.5 cm L 24) Ausf. E (Sd.Kfz. 161).

April 1942 – Soviet tankmen pose with a captured Panzer III near Leningrad.

1941–1942 – The wreckage of a Panzer 39H 735(f) in the Balkan Peninsula. This vehicle was a captured French Hotchkiss H39 which were deployed mainly on secondary fronts.

May 1942 – Soviet infantrymen and officers inspect a Panzer III Ausf. J equipped with a 50 mm L/42 gun. The tank was knocked out by Soviet artillerymen in the Ukraine.

May 1942 – A Soviet KV-1 heavy tank is pictured opposite a burning Panzer IV during the Second Battle of Kharkov.

14 May 1942 – Soviet tankmen operating a captured StuG III Ausf. B (of the 214th Infantry Division) seized from the Germans by tankmen of the 5th Guards Tank Brigade during the Kharkov offensive.

May 1942 – This Panzer IV suffered a direct hit from Russian anti-tank weapons during the Second Battle of Kharkov. Russian infantrymen examine the wreckage.

May 1942 – A Soviet soldier inspects a StuG III captured at Kharkov.

Panzer III Ausf. F from the 10th Panzer Division (Wehrmacht) knocked out on the Eastern Front.

A knocked out Panzer IV Ausf. F2 on the Russian Front. Note the damage to the gun barrel. A pair of Soviet T-34 tanks are seen in the background

September 1942 – Red Army troops inspect a captured Panzer 38(t). This tank probably belonged to the 22nd Panzer Division (Wehrmacht).

1942 – Russian troops inspect a knocked out Panzer IV at Stalingrad.

1942 – Red Army soldiers inspect a captured Panzer III Ausf. L near Stalingrad.

Panzer III of the 24th Panzer Division knocked out near Stalingrad.

1942 – A knocked out Panzer III at Skirmanovo near Moscow. The burnt body of a crew member is seen in the foreground.

September 1942 – Soviet troops towing a captured Panzer 38(t) with a C-65 tractor near Stalingrad.

Circa 1942-1943 – Wrecked Panzer III and dead crew members in Russia.

Winter 1942-43 – Damaged and abandoned Panzer III's and an early Panzer IV Ausf. G (in the foreground) near Stalingrad.

Abandoned Lorraine 37L with a 7.5 cm Pak 40 anti-tank gun at Stalingrad.

February 1943 – Soviet troops inspect a captured Panzer IV at Stalingrad. Many German tanks and other vehicles, captured at Stalingrad, were quickly pressed into service by the Soviets.

1943 – A Panzer III and military trucks lie destroyed in Stalingrad.

1943 – A battery of abandoned Marder II, ('Marder II', Sd.Kfz.131, equipped with with 76.2 mm main guns), captured by Soviet forces in the Stalingrad cauldron.

February 1943 – Soviet troops pass the wreckage of a Panzer IV Ausf. F during the Battle of Stalingrad.

1943 – A Russian soldier inspects a knocked out Panzer IV at Vladikavkaz, Russia.

February 1943 – Abandoned German tanks amongst the ruins of Stalingrad.

February 1943 – The wreckage of a Panzer III Ausf. N in the Sinyavino area of Leningrad.

February 1943 – A Red Army soldier examines a 10.5 cm K gepanzerte Selbstfahrlafette of the Panzerjäger Abteilung 521 seized near Stalingrad.

February 1943 – Children sit atop a knocked out Panzer III near the village of Gulkevichi, Russia.

12 March 1943 – A destroyed Panzer IV Ausf. G of the 1st SS Panzer Division Leibstandarte SS Adolf Hitler in Kharkov. The damage caused by 76 mm shells can be seen on the frontal armour plate.

The overturned wreckage of a Panzer III on the Eastern Front.

1943 – Panzer IV tanks knocked out on the Kursk Bulge.

May 1943 – Soviet teenagers investigating a captured Panzer 35(t) in Leningrad.

July 1943 – Ferdinand (№ 501, 654th Battalion) heavy tank destroyer abandoned by its crew on the battlefield near Ponyri Station.

1943 – Two penetrating hits can be clearly seen on the armour of this StuG.

Remnants of a Panzer III, Ferdinand and Borgward IV in the Kursk salient, near the village of Glazunovka.

July 1943 – A knocked-out Panther lies on the battlefield at Kursk. The wreck has been most likely signed by the Russian who knocked it out to make certain that he got proper credit for the kill

1943 – A Soviet infantryman poses beside a knocked out StuG 40 Ausf. G.

July 1943 – Knocked-out Ferdinand heavy tank destroyers of Schwere Panzerjäger-Abteilung 654 near Ponyri Station.

A Soviet T-70 passes the wreckage of a Panzer IV in the Kursk salient.

1943 – Panzer IV tanks under fire on the Eastern Front. The Panzer IV to the left appears to have lost its caterpillar.

Summer 1943 – A Ferdinand heavy tank destroyer of the 653rd Heavy Panzerjäger Battalion devastated by an internal explosion at Kursk.

1943 – Soviet collective farmers at work in the field in front of a knocked out Ferdinand in the Ponyri Station district.

July 1943 – A knocked out Panzer III Ausf. M near the village of Ponyri.

1943 – Soviet troops pose around a knocked out Panzer IV with a turret skirt penetration.

July 1943 – The wreckage of a Sturmpanzer 'Brummbär' of the Sturmpanzer-Abteilung 216, in the vicinity of the Ponyri railway station.

Red Army infantrymen pose on the skeleton of a destroyed Panzer IV. Some of the men are armed with VIM-203 mine detectors.

Destroyed and abandoned *Elefant* heavy tank destroyers at Kursk. In the foreground of the photograph below is the shell of a Sturmpanzer 43 (Sd.Kfz. 166). Based on the Panzer IV chassis it was deployed at Kursk, Anzio, Normandy and during the Warsaw Uprising. It was given the nickname *Brummbär* by Allied intelligence, a name which was not used by the Germans.

July 1943 – Red Army infantrymen inspect a Panther Ausf. D (No. 824) of the 52nd Panzer Battalion captured during the fighting at Kursk.

July 1943 – Soviet troops and commanders inspect a pair of knocked out "Ferdinand" tank destroyers in the Kursk salient.

July 1943 – Front-line correspondent Konstantin Mikhailovich Simonov (1915-1979) sits on the trunk of the gun of a captured Ferdinand (No. 232) in the northern sector of the Kursk Bulge.

The turret of a detroyed Tiger at Kursk.

July 1943 – Soviet troops investigate the wreckage of a Panzer IV Ausf. H north of the city of Orel. The tank is painted in three-colour camouflage. The same tank is seen from a different angle below.

July 1943 – Soviet servicemen inspect a Panzer IV, which was knocked out on the Kursk Bulge.

July 1943 – Knocked out Panther (No. 434) of the 51st Wehrmacht Tank Battalion, at the Kursk Bulge

1943 – A deceased crewmember lies beside the still burning wreckage of a Panzer IV.

A German tank, possibly a Panther, the victim of an ISU-152.

1943 – Soviet infantrymen take cover behind the wreckage of a Panther (No. 315) during an advance at Kursk. The tank was knocked out by artillery fire and blown up by the Germans during the retreat.

July 1943 – The wreckage of a Panther Ausf. D (No. 312) of the 51st Panzer Battalion near Prokhorovka, 87 kilometres southeast of Kursk. Red Army troops inspect the tank in the second photograph.

23 July 1943 – Soviet tank commander Lt. B.V. Smelov points out the damage inflicted upon a Tiger by an ordinary armour-piercing shell of a 76-mm tank gun to his colleague Lt. V.L. Lihnyakevich.

August 1943 – A internal explosion has doomed this Panther Ausf. D-2 (No. 322). Another Panther sits abandoned nearby on the battlefield.

August 1943 – Red Army infantrymen pass the wreckage of the same Panther Ausf. D-2 (No. 322) of the Panzer Grenadier Division *Großdeutschland* near the city of Karachev, Russia.

August 1943 – A Panzer-Abteilung 51 Ausf. D waiting to be shipped back for repairs after being knocked out by a anti-tank gun ambush in Ukraine.

August 1943 – Destroyed German armour in the aftermath of the Battle of Kursk. In the foreground is the wreckage of a Panzer II.

23 August 1943 – Soviet troops inspect a Panther destroyed during the fighting near Prokhorovka.

August 1943 – Soviet tankmen pose with a 'Ferdinand' tank destoyer of the 653rd Heavy Panzerjäger Battalion, captured in good order, along with the crew, in the Kursk salient.

1943 – Wrecked armour in the aftermath of the Battle of Kursk.

15 September 1943 – A Soviet infantryman examines a Tiger I (No. 500) belonging to to the Schwere Panzer Abteilung 505. The tank was seized by the Red Army near Orel, Russia.

November 1943 – The wreckage of a Tiger (No. 331) belonging to the 509th Heavy Panzer Battalion near Kiev.

1943 – Soviet forces pass the wreckage of a Panzer IV. Note the ZiS-3 gun being towed by the horses.

1943 – Panzer III tanks defeated in Konotop, Ukraine. A Soviet T-34 is seen in the background.

Wrecked Panzer III Ausf. G on the Eastern Front.

Destroyed German armour litters the battlefield during the winter of 1944. The wreckage of a Panzer IV can be seen in the foreground to the left.

November 1943 – Officers of the 238th Artillery Brigade inspect a captured StuG III Ausf. G in a pine forest near the village of Pushcha-Vodytsia in the outskirts of Kiev, Ukraine.

December 1943 – Panzer IV Ausf. G tanks abandoned in Zhytomyr, Ukraine. The tank in the foreground is painted white and has the tactical number '529', whilst the other carries the tactical number '748'.

Winter 1943-1944 – Abandoned Panzer IV Ausf. H tanks on the Eastern Front

1944 – German armour and property abandoned in the Korsun–Cherkassy Pocket. A field kitchen and carts lay beside a Panzer IV Ausf. F2.

Winter of 1943-1944 – Tiger I with a damaged track on a roadside in Russia. Note the Kübelwagen in the background.

February 1944 – A knocked out Tiger Ausf. H of the 502nd Heavy Panzer Battalion lies in the snow near Leningrad. Most likely, this tank was hit in the winter of 1943.

February 1944 – The Red Army infantrymen inspect an abandoned Marder III tank destroyer on the Ukrainian Front.

Sumy partisans inspect a collection of damaged German armoured vehicles. In the foreground is the turret of a Panzer IV.

A Red Army infantryman inspects a captured Panzer IV Ausf. F2.

Soviet infantrymen pass a burning Tiger during an advance.

1944 – A knocked Panzer IV Ausf. H in the Leningrad region.

1944 – StuG III knocked out by Soviet artillery during the Battle for Leningrad.

13 March 1944 – Russian troops, ankle deep in mud, inspect a Panther Ausf. A left behind by the Germans in Uman, Ukraine. Uman was a popular site for Russian propagandists, and a harbinger of the German retreats to follow in the summer of 1944.

March 1944 – Soviet troops inspect German armour captured in the city of Khmelnytskyi, Ukraine. To the left is a StuG IV, and to the right a StuG III.

1944 – A pair of Wespe self-propelled howitzers knocked out near the city of Zhytomyr, Ukraine.

March 1944 – A knocked out Panther on the Eastern Front.

March 1944 – Damaged and dismantled Tiger of the of the 3rd company of the 503rd Heavy Panzer Battalion, captured by Soviet troops at the railway in the city of Kopychyntsi, Ukraine.

March 1944 – The wreckage of a Panzer IV Ausf. H belonging to the 1st SS Panzer Division Leibstandarte SS Adolf Hitler in Khmelnytskyi, Ukraine.

1944 – *Sturmhaubitze* 42, with tactical number '308', abandoned by its crew in Ukraine. A variant of the StuG Ausf. F, the StuH 42 was designed with a 105 mm true howitzer instead of the 7.5 cm StuK 40 L/43 cannon.

April 1944 – A Soviet ZIS-5 truck passes an abandoned Panzer IV in the city of Khmelnytskyi, Ukraine. On the left is the rear of a knocked-out Panther.

April 1944 – Abandoned Panthers in Khmelnytskyi.

April 1944 – A Soviet soldier on a horse-drawn cart passes a knocked out Panzer IV in a village in the Kamianets-Podilskyi area, Ukraine. The tank has been marked 'UA 434' by the Soviets.

June 1944 – A Red Army infantryman inspects a pair of knocked out Panzer IV tanks, belonging to the 20th Panzer Division, at the pocket of Babruysk. The dead crew members are seen in the foreground.

June 1944 – A column of German equipment, including a Panzer IV, destroyed near Babruysk. The body of a German soldier lays in the foreground.

1944 – Sd.Kfz. 247 Ausf. A knocked out and abandoned near Dnipropetrovsk, Ukraine.

1944 – Defective Panzer IV Ausf. H abandoned in a street in Zhytomyr, Ukraine. The machine has been dismantled for spare parts.

1944 – An abandoned Panzer IV Ausf. H alongside a Wurfrahmen 40 installed on Sd.Kfz. 251/1 Ausf. B in Ukraine.

1944 – Panthers of the 5th SS Panzer Division *Wiking* abandoned in swampy conditions in Ukraine.

1944 – The corpse of a German soldier next to a wrecked Sd.Kfz. 251 Ausf. D in Belarus.

July 1944 – Wrecked Hummel self-propelled howitzer near Lviv. It belonged to the 80th Artillery Regiment of the 8th Panzer Division – the division lost eight of these guns.

1944 – The wreckage of a Panzer IV Ausf. J near the city of Lviv in western Ukraine. A column of Soviet Studebaker US6 trucks are seen moving past the damaged tank.

August 1944 – A knocked out Tiger in the Lviv region of western Ukraine. The Tiger is missing its left caterpillar. A Panther is in the background.

1944 – A Befehlspanzer Panther knocked out in Karelia.

August 1944 – Belarusian children pose with an abandoned Tiger near Minsk. The planes seen flying overhead were added to the image with the aid of mounting.

1944 – Red Army infantrymen inspect the muzzle break of a knocked out Panzer IV.

August 1944 – Tiger Ausf. B knocked out near Sandomierz.

August 1944 – A Soviet sentry poses in front of the wreckage of a Panzer IV Ausf. J in the Ukraine.

The wreckage of a StuG III Ausf. B knocked out on the Eastern Front.

September 1944 – A knocked out StuG 40 in Tallinn, Estonia.

1944 – Various German armour killed at Stalingrad. Left to right: Panzer III Ausf. J with a long gun (5 cm KwK 39 L/60), Panzer IV Ausf. D, Panzer III Ausf. J with a short cannon (5 cm KwK 38 L/42).

14 September 1944 – Polish children inspect a Panzer IV, burnt by the rebels during the Warsaw Uprising.

10 October 1944 – Tiger Ausf E of the 507th Heavy Panzer Battalion killed by Soviet troops on the Narew bridgehead, Poland.

18 October 1944 – Curious civilians inspect a wrecked StuG III on the Boulevard of Liberation in Belgrade, Yugoslavia. This photograph was taken during the height of the battles for the city.

October 1944 – The bodies of fallen soldiers lay beside the wrecakge of a Sd.Kfz. 10/5 half-track near Tehumardi, on the island of Saaremaa, Estonia.

1944 – This Panzer IV, photographed in Romania, was clearly knocked out by several high velocity impacts from the rear.

Abandoned Panzers of all types litter the roads during the retreat back into Germany.

January 1945 – The wreckage of a Panzer IV Ausf J on the Eastern Front.

Soviet soldiers inspect a knocked out Jagdpanther in East Prussia.

January 1945 – StuG IV with side shields knocked out in East Prussia.

Knocked out Panzer IV (Ausf. H or J) which has been dismantled for spare parts.

1945 – Children are posing on the Wehrmacht tank "Panther", abandoned near Címer, Czechoslovakia.

Knocked out StuG III Ausf.G on the Eastern Front.

1945 – Panzer IV Ausf. H knocked out during Siege of Breslau, in Lower Silesia, Germany (now Wrocław, Poland). The burnt out tank was hit by a 76-mm armour-piercing shell in the tower.

1945 – The burnt wreckage of a Panther in Budapest.

A burnt and dismantled Panzer III amongst the devastation in Budapest.

February 1945 – Knocked out Panther Ausf G in Poznan.

6 February 1945 – German 150-mm self-propelled heavy field howitzer Sd.Kfz. 165 'Hummel', destroyed by Soviet troops in the Polish town of Brzeg.

February 1945 – Abandoned Sturmpanzer 'Brummbär' in East Prussia.

This Panther fell victim to a high caliber HE shell. The shell ricocheted off its upper front plate, but left a breach and cracks in the armour. The tank was abandoned by its crew at Lake Balaton, Hungary.

1945 – Tiger Ausf. E knocked out by Soviet units in East Prussia.

February 1945 – The wreckage of a StuG III, captured by the troops of the Third Army in East Prussia.

February 1945 – The wreckage of a Sd.Kfz. 10/4 with a Flak 38 20 mm anti-aircraft gun in East Prussia.

1 March 1945 – Dead German soldiers lie alongside a knocked out Tiger II in Pomerania.

March 1945 – Tiger II knocked out in the area of Lake Balaton, Hungary.

March 1945 – The wreckage of a Jagdpanzer IV destroyed near Lake Balaton.

March 1945 – Panzer IV Ausf. H of the 9th SS Panzer Division "Hohenstaufen" at Lake Balaton.

A frozen Panther Ausf G at Lake Balaton.

March 1945 – Tiger II of the 509th Heavy Panzer Battalion, knocked out at Lake Balaton, Hungary. The tank has lost its gun barrel. Two shell penetrations are marked with white paint.

March 1945 – A *Hummel* captured in Budapest by the Red Army. The wall of the building in the background, covered with bullet and shell holes, is evidence of the fierce fighting that took place.

March 1945 – German armour, including a Panzer IV and StuG III captured by Soviet forces in Székesfehérvár, Hungary. The tanks were abandoned due to lack of fuel.

1945 – The wreckage of a Panther Ausf. G on the Eastern Front. The Panther was the third most produced German armoured fighting vehicle, after the Sturmgeschütz III and the Panzer IV

1945 – Destroyed StuG 40 Ausf. G with a large AT shell hole on its 80mm front hull in East Prussia.

March 1945 - A knocked out Jagdpanzer IV-70(V) in Southern Silesia, close to the Czech border.

1945 – Destroyed in the Berlin area assault gun StuG III

Abandoned Panther Ausf. D on the Eastern Front.

March 1·945 – An abandoned Sturmpanzer "Brummbar" (No. 222) in Hungary. In the background there is another "Brummbar" (No. 110).

March 1945 – A Panther Ausf. G of the 3rd SS Panzer Division Totenkopf knocked out by troops of the 3rd Ukrainian Front near the village of Magyaralmás, Hungary.

March 1945 – Panzer IV Ausf. J destroyed during a raid by Soviet assault aircraft in Hungary. The number of the Soviet trophy team '122' is marked on the trunk of the gun.

March 1945 – This Tiger II of the 503rd Heavy Panzer Battalion was the victim of an aerial bomb in Danzig (now Gdańsk, Poland).

1945 – A knocked out StuG 40 in East Prussia. It seems the vehicle suffered an internal explosion.

Wrecked Jagdpanzer 38 'Hetzer' on the Eastern Front.

1945 – A knocked out StuG III in the Courland region of Latvia.

1945 – Various German armoured vehicles captured by the Soviets in Budapest.

1945 – Jagdpanzer IV 70 tanks (V) (Sd.Kfz 162 1) stricken on the outskirts of Berlin.

1945 – Children sit atop an abandoned Jagdtiger (No. 323) of the 653rd Heavy Panzerjäger Battalion in Neustadt, Germany. The vehicle suffered an engine malfunction on 23 March.

1945 – A damaged Panzer IV (No. 217) lies beside various ruined German armour and equipment in the Charlottenburg area of Berlin.

March 1945 – A pair of an abandoned Sturmpanzer 'Brummbär' heavy assault guns in Hungary. Armed with a 15 cm StuH 43 L/12 the 'Brummbär' was nicknamed 'The Bear' by the Soviets.

April 1945 – Jagdpanzer 38 'Hetzer' light tank destroyers abandoned in Silesia.

April 1945 – *Waffenträger* of the Eberswalde tank destroyer company, captured by units of the Red Army in the Märkisch Buchholz area (approximately 50 km southeast of Berlin).

1945 – Berlin residents observe the devastation that surrounds them beside the wreckage of a Tiger.

April 1945 – Knocked out armour of Waffen SS Division Nordland in a Berlin street following Nordland's desperate, but failed, attempt to break out of the Russian encirclement.

April 1945 – A knocked out StuG III amongst the devastation in Fischhausen, East Prussia.

2 May 1945 – A smashed armoured personnel carrier Sd.Kfz 250 belonging to the 11th SS Volunteer Panzergrenadier Division Nordland in Berlin.

Destroyed tank dump in the aftermath of the Battle of Berlin. Two Tiger II's, a Panther, a SU-76 self-propelled gun, two Shermans, several IS-2's and a a T-34/85 can be seen.

May 1945 – German ammunition transporter on the chassis of a Panzer IV abandoned on Charlottenburger Chaussee in Berlin. The Victory Column monument is seen in the background.

May 1945 – Red Army officers of the 359th Infantry Division pose against the backdrop of captured German armour in Breslau, Germany. In the foreground is a Marder III, and in the background a Tiger II.

May 1945 – A wrecked late version Panther in Czechoslovakia. The turret sides were lined with tracks for extra protection, but it clearly wasn't enough.

May 1945 – Two Soviet tankmen posing in front of an abandoned Tiger II of the 502nd Heavy Panzer Battalion in the Seelow Heights area, Germany.

1946 – Settlement of broken and dismantled German armour vehicles in Hungary. In the foreground you can see the gun of a Soviet SU-85, on the left a Panther, and on the right a Panzer IV.